Million star hotel

by Rory Motion

Earth my bed, sky my groovy
Fluffy pillow clouds below m
Earth my bed, sky my groovy duvet
And these flat fields are my fabulous
Flower and forest-patterned fitted sheets
Stretching across the vast elastic fatness
Of the planet's fantastic mattress
Earth my bed, sky my groovy duvet.

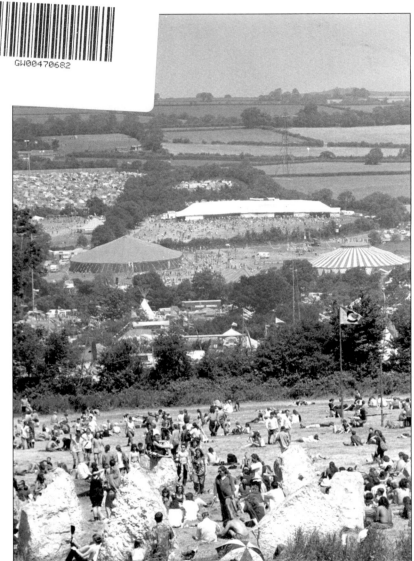

The view from the stone circle. From our vantage point we seem to look out between the fractured molars of a giant mouth, as if the Ancient of Days were exhaling, breathing the festival into existence… the three-day city, mythical metropolis, with ring-road, market place and strange suburbs. The festival has also been called 'the city that never sleeps' – many of its temporary citizens are refugees from cities that never wake up.

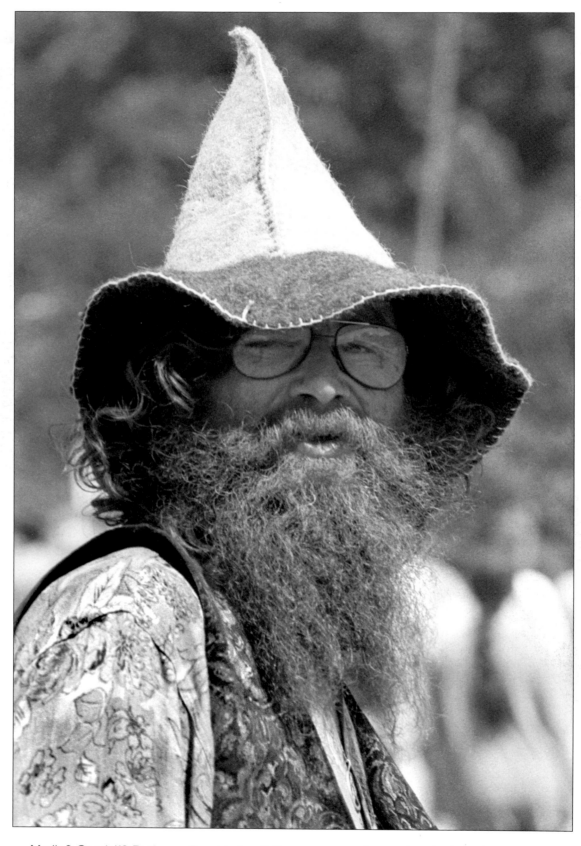

Merlin? Gandalf? Professor Dumbledore? The name may change, but the beard remains the same. At Glastonbury archetypes take form and mingle with the crowd, but few would guess that this man is a probation officer for Shepton Mallet Social Services.

FOREWORD

Probably best known as the title of a song by Jimi Hendrix, 'Stonefree' seemed like the ideal business name for a free-lance photographer known as Stone, so I took the liberty of borrowing it. The concept of a book of photos from Glastonbury came about during the 2000 festival, ten years after my first one, but I struggled to find anyone willing to take it on until nearly two years later, when I moved to Devon. I was lucky enough to find a small pad to rent in Sandford, and even luckier to discover that my closest neighbour was a publisher. I told him my idea, showed him the photos and suddenly we were putting it all together, just four months before the festival. Thanks Drum.

The photograph of the girl on the stone was taken in 1993 and was the obvious choice for the cover of the book, because it captured something of the festival spirit. However, I was in two minds about calling it 'Stonefree' until I was given a copy of the programme from 1999. It fell open at an article about the festival history, and synchronicity stared me in the face. It read: "The first Glastonbury Festival was held on 19th September 1970… that morning it was announced that Jimi Hendrix had just died." No more doubt about the book title then: 'Stonefree' it is. Thanks Jimi.

After a week of racking both brain cells trying to write some decent captions for the photos, I went to a 'Comedy Night' at my new local, The Lamb. Synchronicity was apparently leading me by the hand yet again: not only were comedians Rory Motion and Matt Harvey very funny, they were light-hearted yet deep; silly yet profound; morecambe yet wise. More importantly, they had material inspired by Glastonbury Festival. No more doubt about captions for the book then: Rory and Matt it is. Thanks guys.

It's amazing how sometimes events seem to weave themselves together, as though they have a life of their own, but we can also become a catalyst for things to happen, if we believe in something enough and follow our hearts. To me, Glastonbury seems to be a place with the potential for such reactions to start. Whether it's because so many like-minded people gather there, and whether they are somehow drawn there because of some 'spirit of place' nobody knows for sure, but the whole area is steeped in history, myth and legend. The year before my first visit to Glastonbury, I had become fascinated by the Arthurian Legends and read quite a variety of books on the subject, so my first trip was only partly for hedonistic reasons, but also because of a yearning to find out more – what some would call a 'Quest'. Did I discover the location of Avalon, or the Sword in the Stone, or the secret of the Grail? Who knows, but I did learn that the archetypes encoded within many ancient tales can help us discover the nature of our true selves, and that asking the right questions is often more important than finding the answers.

The photos in this book are just a few images from a small part of one fool's journey through this life, but as any fool can tell you, the real journey is the one within. Have you booked your ticket yet?

Roy 'Stone' Naylor

"Our meddling intellect mis-shapes the beauteous forms of things: We murder to dissect"
William Wordsworth (from *The Tables Turned*)
"But we really enjoyed it. Cheers"
Matt and Rory

Setting the Scene
by Matt Harvey

Let's amble down Imagery Avenue
Meander down Metaphor Mews
We'll gaze at the skies up at Prophecy Rise
And light a soft, spiritual fuse

We'll trip on tiptoes down Controversy Close
Quite disturbed by the people we meet
We'll skip very lightly whilst shivering slightly
Down Subtle & Sensitive Street

We'll get all effervescent on Ecstasy Crescent
Stroll vainly down Looking Glass Lane
We'll be shedding our load down Catharsis Road
Achieving temporary cessation of pain

We'll become self-aware round at Consciousness Square
Of the being beneath all we do
Then talk out of our arse at Brain-Stem By-Pass
And al*most* go down Virtual View

We'll be broadcasting live from Dysfunctional Drive
With efforts both whole and half-hearted
We'll get all self-important at Self-Centred Court and
Then all meet up back where we started

I'm a Hippie
by Rory Motion

I believe in angels and reincarnation
I believe the pyramids contain coded information
I believe imagination is the true source of wealth
I believe in glasses from the National Health

I believe in the benefits of retaining vital fluids
I believe Ken Barlow in real life's a druid
I believe that Jesus sometimes liked a joke
I like to think that Prince Charles has maybe had a toke

I believe in the lost continents of Atlantis and Mu
I believe in tahini, tai chi and tofu
I believe there's a secret language in the stones
I believe in infinity and wholemeal scones

I believe in gnostics, josticks and karma
I believe in Captain Beefheart and the Dalai Lama
I believe bees come from outer space
I like to think that kindness could save the human race

I believe it is below as it is above
I believe Glastonbury in real life's a dove
I believe in flapjacks and fingerless gloves
I believe in bare feet, barleycup and Love

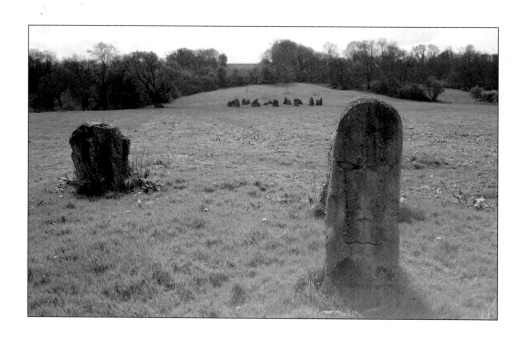

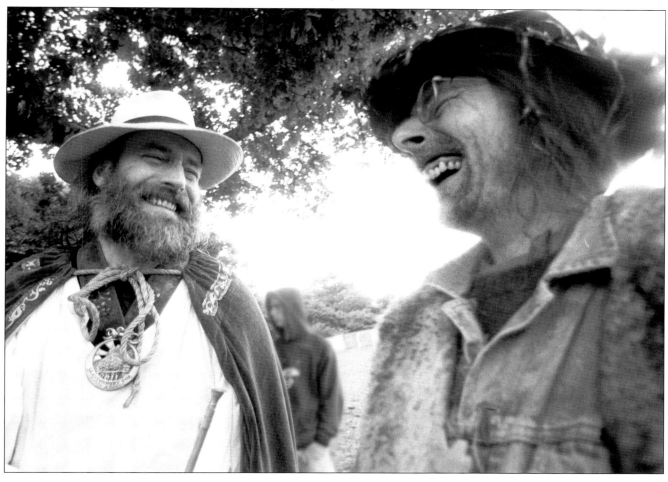

Druids seeing the funny side of two thousand years of denigration, marginalisation and persecution beneath the sensible shoes of monotheism and mechanistic rationalism. Demographically, Glastonbury Festival has a higher proportion of people who were nick-named 'Catweazle' at school than any other gathering.

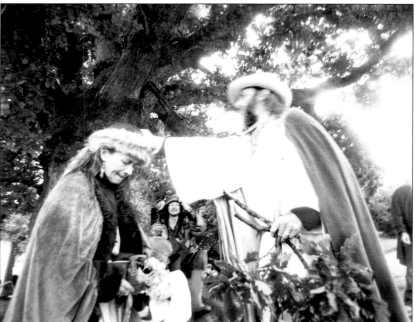

Beneath the boughs of an ancient oak a threshold is crossed. The young novitiate bites her lip as the Arch Druid dabs her ear with ritual tea-tree oil. The sprig in his hand symbolises all the emotional housework the priestess will do in her lifetime, unthanked, unacknowledged.

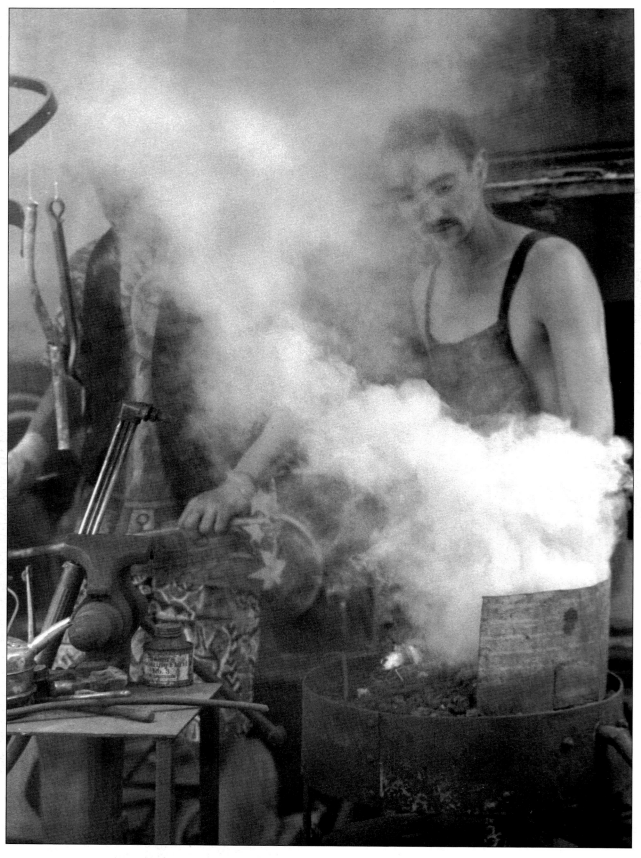

As the saying goes, 'There's no smoke without altered states of consciousness'.
Here we see two amateur alchemists turning base mental states into gold.

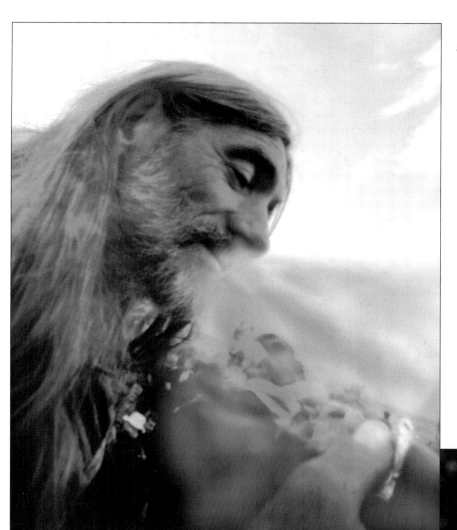

If you laid every joint smoked during the festival end to end, you could be busted by the police forces of Wiltshire, Somerset, Dorset, Cornwall and Devon.
This man is the voice of the Glastonbury speaking clock.
"At the third toke it will be now, the present, precisely…"

For many people their first visit to the festival is like falling down the rabbit hole into Wonderland. Here this Mad Hatter/March Hare hybrid twinkles shyly into the camera like a coquettish Des Lynam.

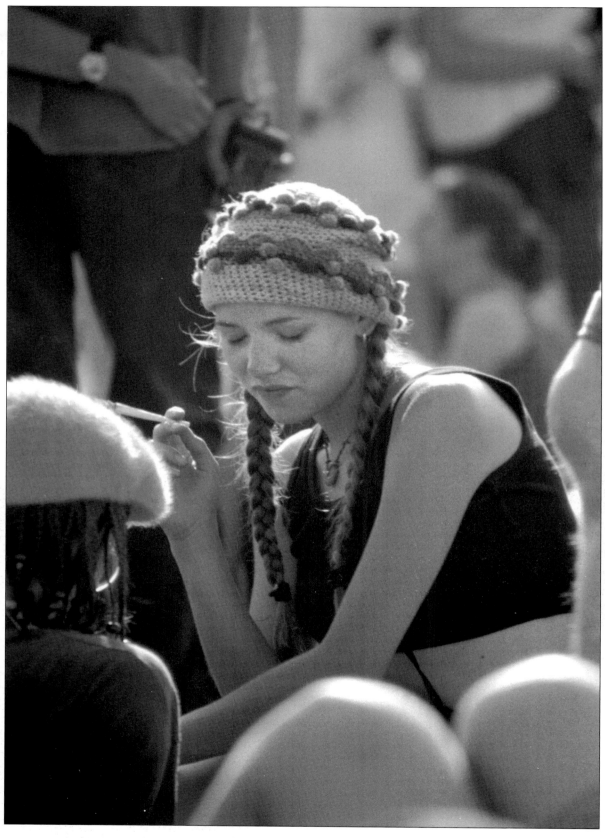

She inhales, shuts her eyes and seems to dream. Is she decoding the cave paintings of her
skull, grafitti from an ancient aerosol? Is she digesting news just in from somewhere
deep beneath her skin? Or has she just got smoke in her eyes?

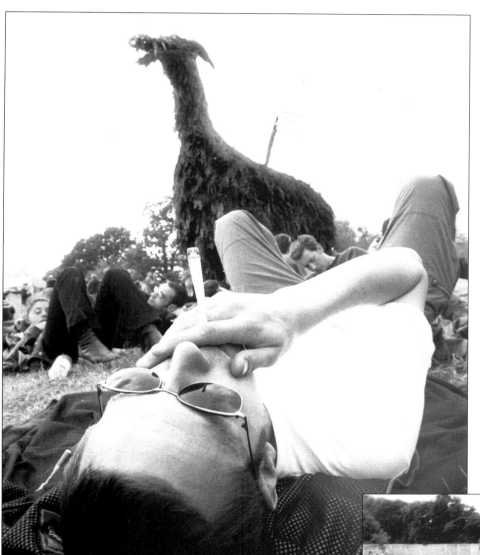

Some people say that use of cannabis leads on to harder things, but we don't think this is true – unless you count the ground. Usually it leads on to softer things, like poetry, cushions and chocolate cake.

Go on without me, I've twisted my mind.

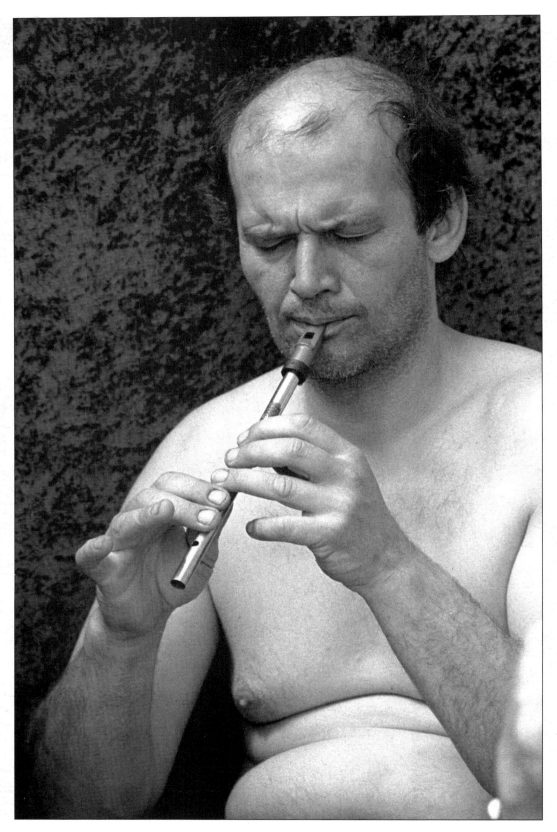

This man is aligning his chakras with Celtic harmonics.

NB: All photos and text in this book are the produce of more than one chakra.

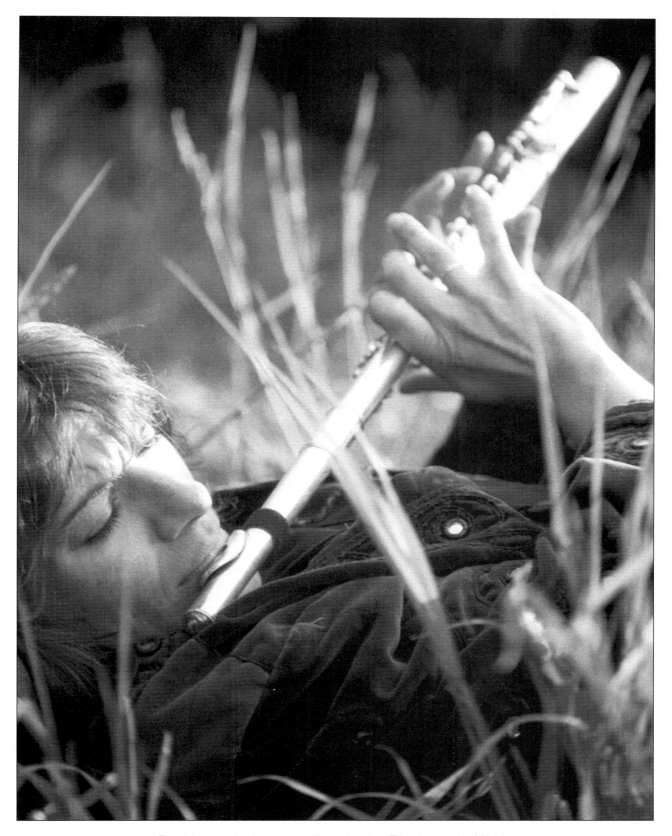

Teaching reeds the correct fingering for 'Blowing in the Wind'.

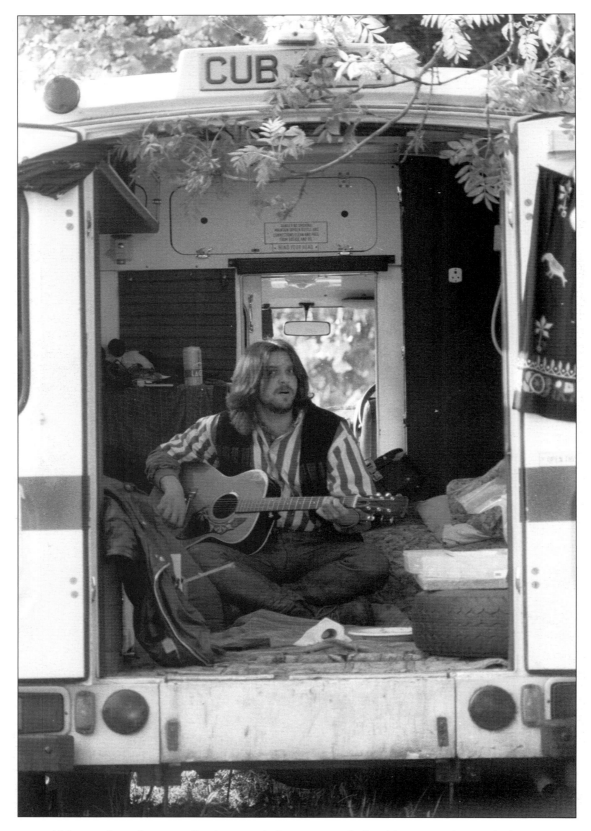

This man has chosen to live in an ambulance to symbolise his sense of woundedness.
He keeps vigil in song beside the sad and disempowered in society.
He has been searching for the lost chord since 1973.

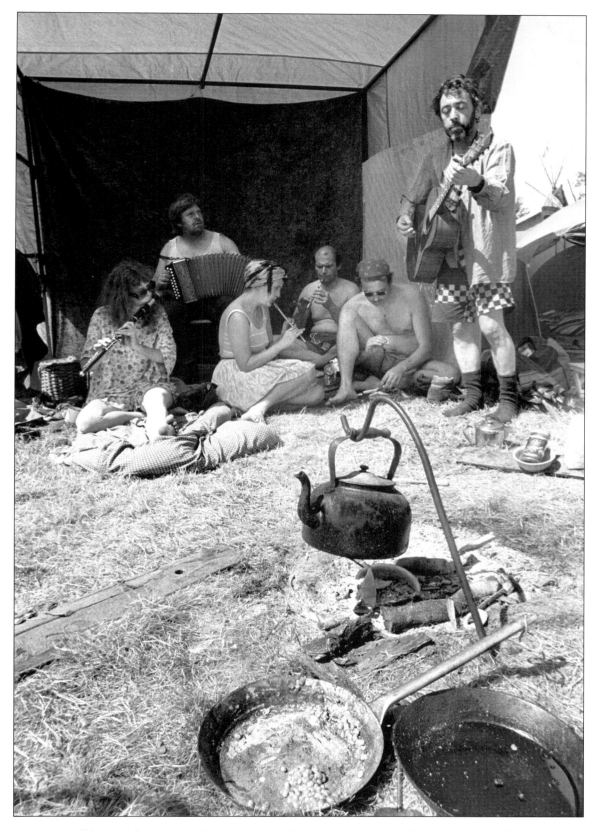

Six musicians serenading a kettle, which becomes too self-conscious to boil.

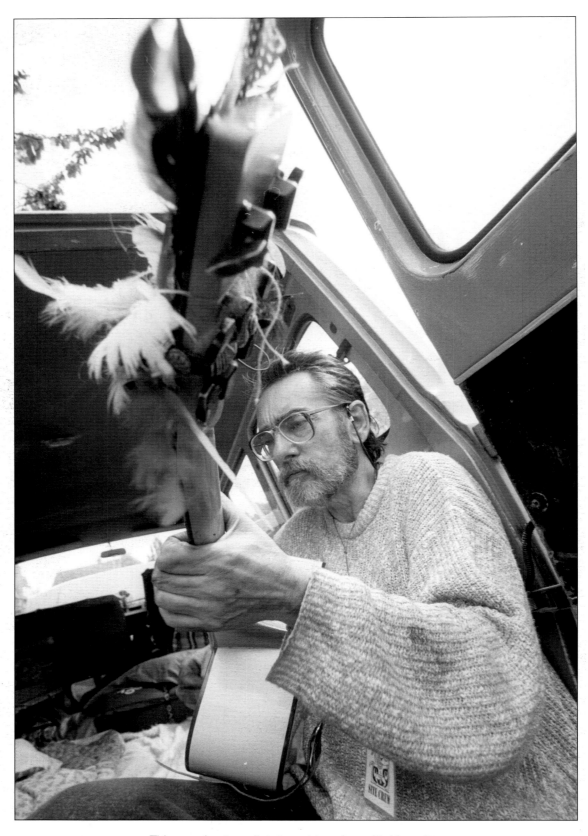

This man is struggling to get to grips with his guitar,
which recently went on a shamanism workshop without him.

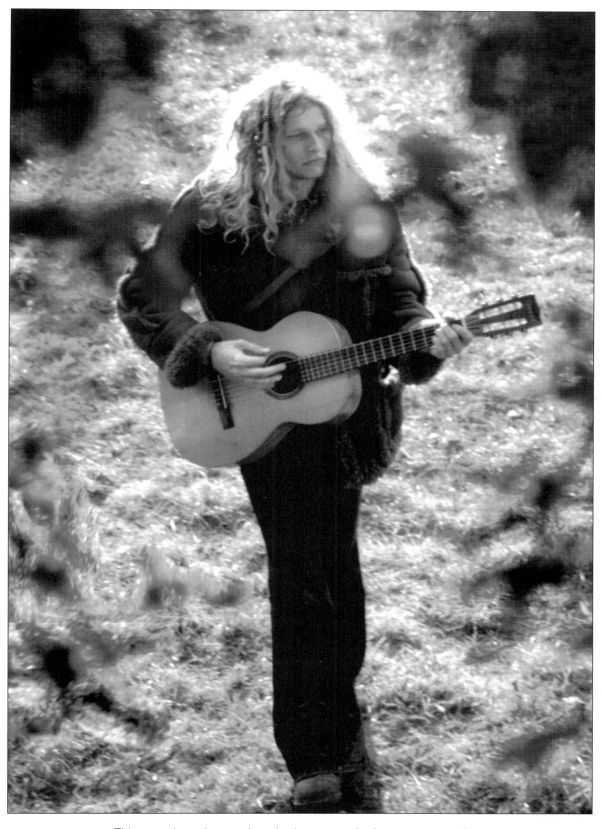

This rare singer/songwriter shrub grew up in the exact spot where
Robert Plant spilled his seed in 1974.

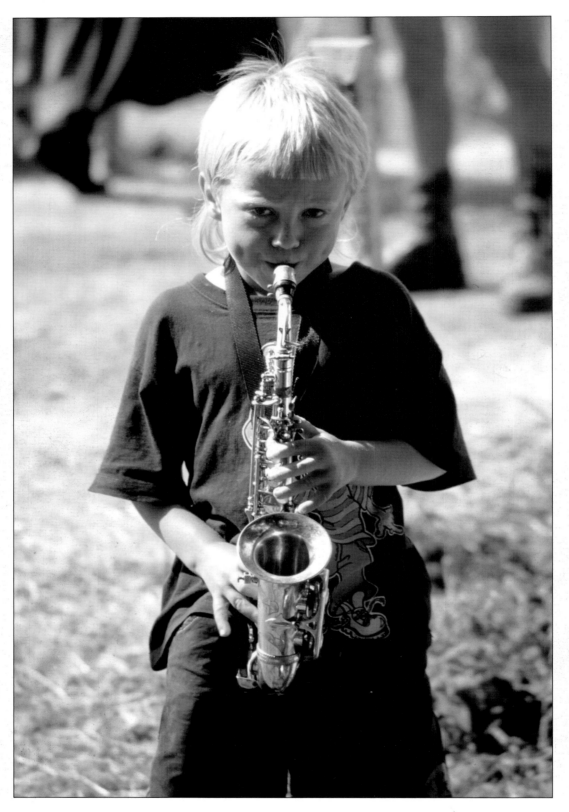

It's not a toy; it's not a complicated ice-cream cone. This little boy blue really can blow his horn. "The kid", says Stone, "can *play*". Remember, you heard him here first. Sort of.

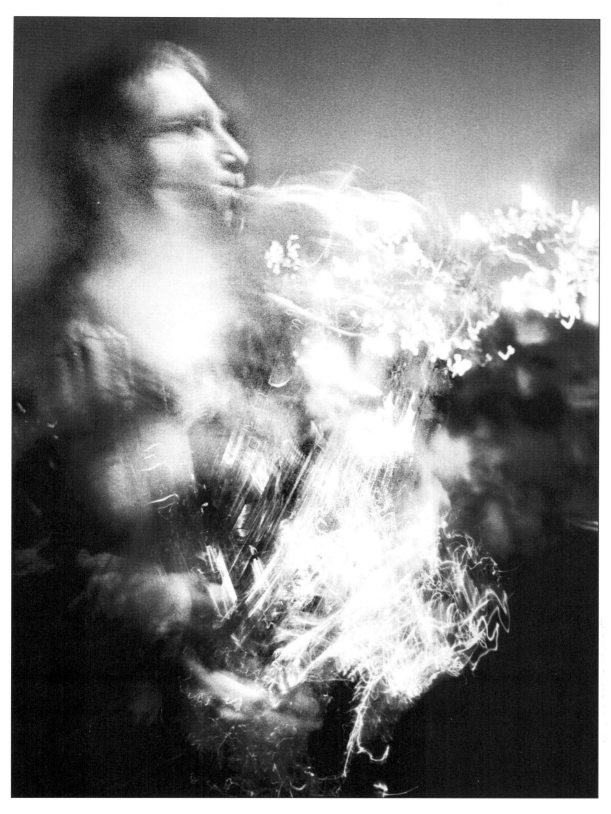

This is a picture of a saxophonist with camp-fires reflected on his sax. Stone achieved this fire-eating, 'oo-er' ectoplasm effect using a long exposure, following him for 30 seconds with the shutter open. Many people come to Glastonbury specifically to open their shutters for prolonged exposure to reflected and refracted light, and, on returning home, can't quite close their shutters as tightly as before. This may be no bad thing.

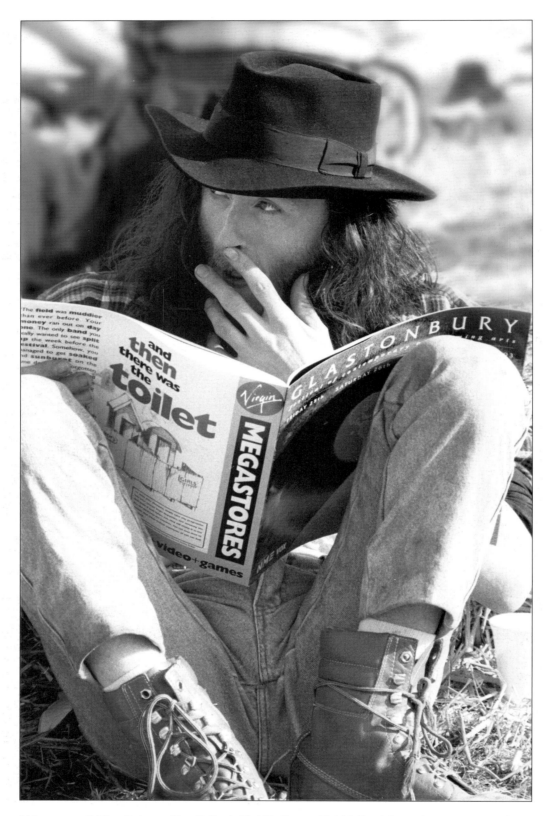

Where next? The Cabaret Tent? Craft Field? Green Field? Deciding what to do next (and whether) can be difficult and demanding. Some bring their I Ching with them, some seek signs and portents in the entrails of spilt rice and dahl, while others find guidance through scrutinising the contents of their noses. A good foretelling bogey is invaluable and will be retained in the nostril 'til the end of the festival.

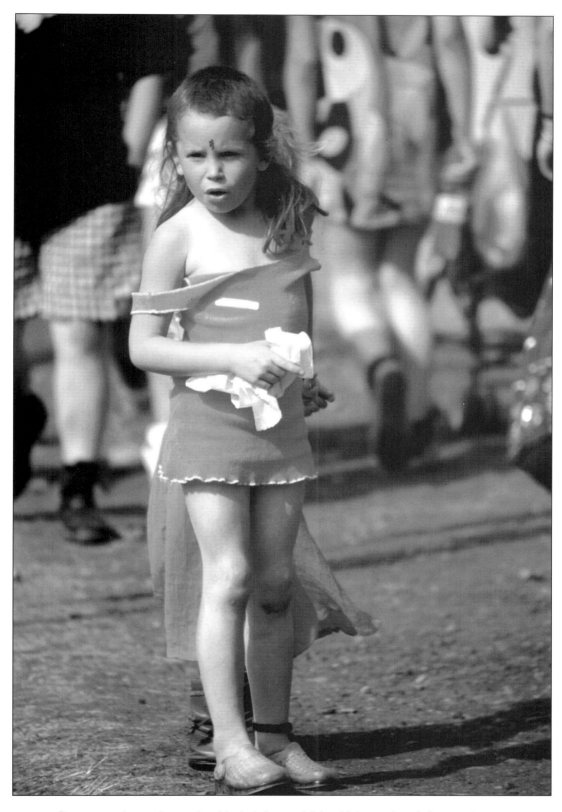

Some people get in touch with their inner child, which can break free and roam
unsupervised through the festival, looking for a toilet. At the end of the festival all the children
are rounded up, their faces are washed, and parents get to claim the
ones they recognise. There are always a few left over.

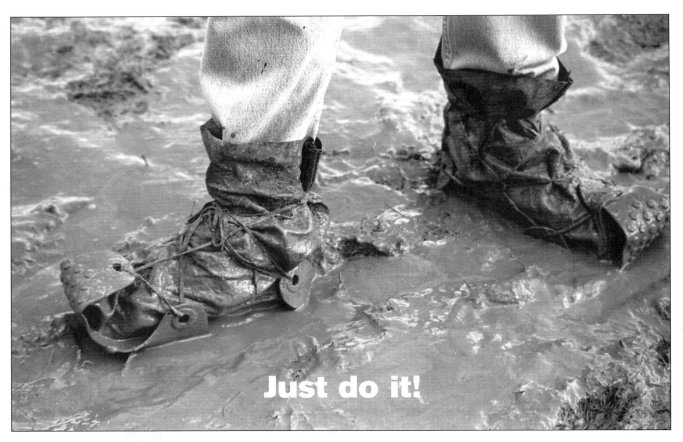

Just do it!

Some people think King Arthur was a 6th Century footballer, the captain of Glastonbury Albion, who won the Holy Grail three times in a row. Arthur is rumoured to have been out for 1400 years with a groin injury, but is expected to return when most needed.

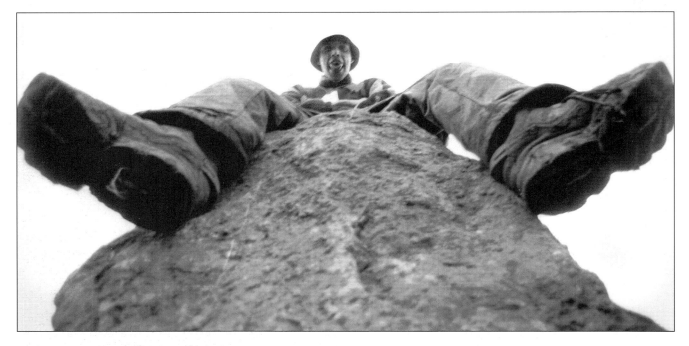

It is said of old: "He who shall remove the sword from the stone shall be King hereafter." It is not recorded what shall become of he who accidentally sits on the sword in the stone, but it's thought he shall not be up to much hereafter, until the Knights of the St. John's Ambulance Brigade arrive with rescue remedy and comfrey cream.

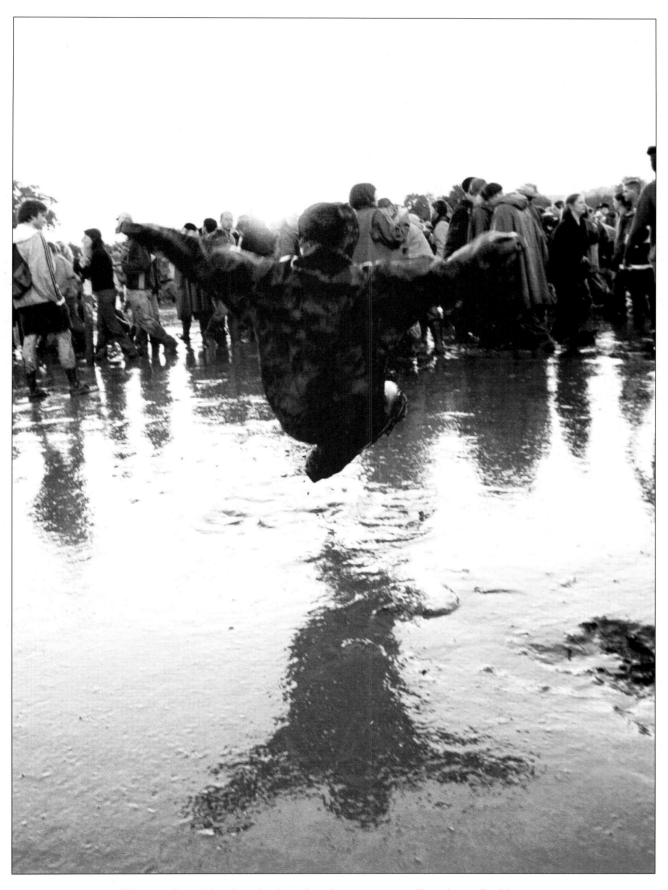

This man is celebrating the fact that the tent pegs will go in easily this year.

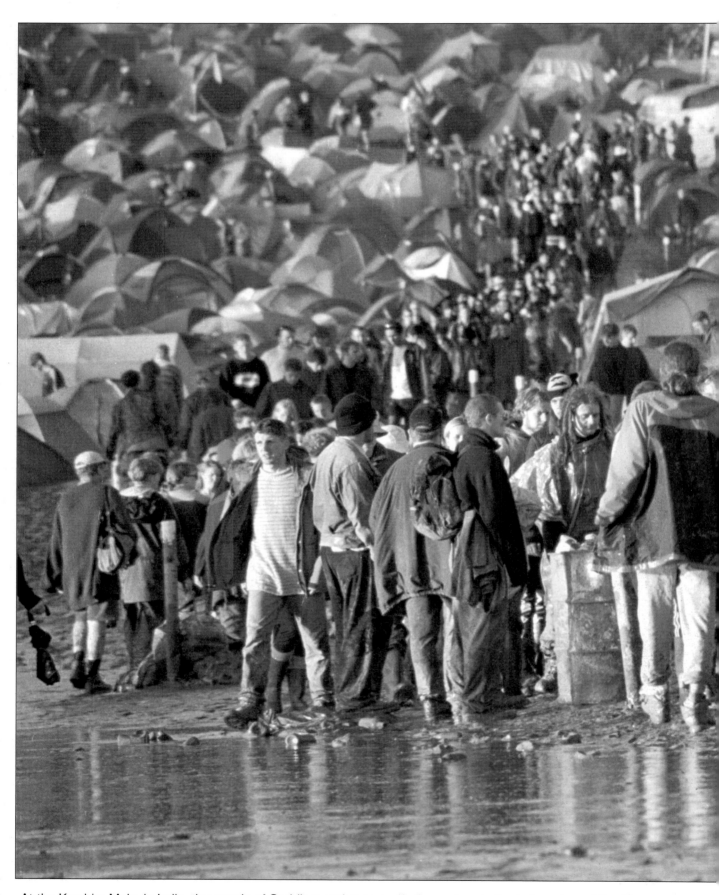

At the Kumbha Mela, in India, thousands of Saddhus gather to purify themselves in the holy waters of the Ganges.

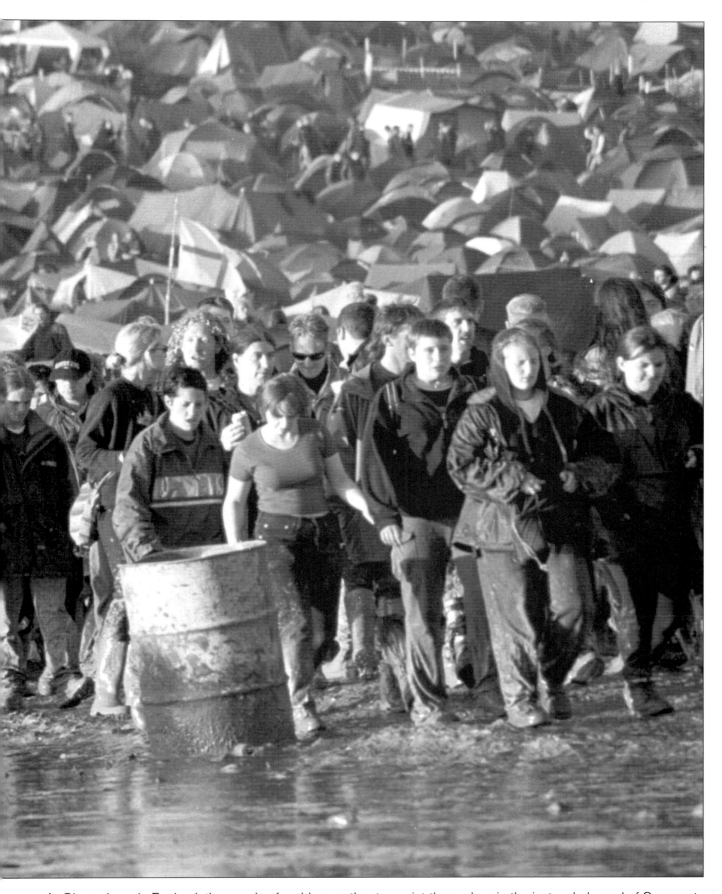

At Glastonbury, in England, thousands of saddoes gather to anoint themselves in the just-as-holy mud of Somerset.

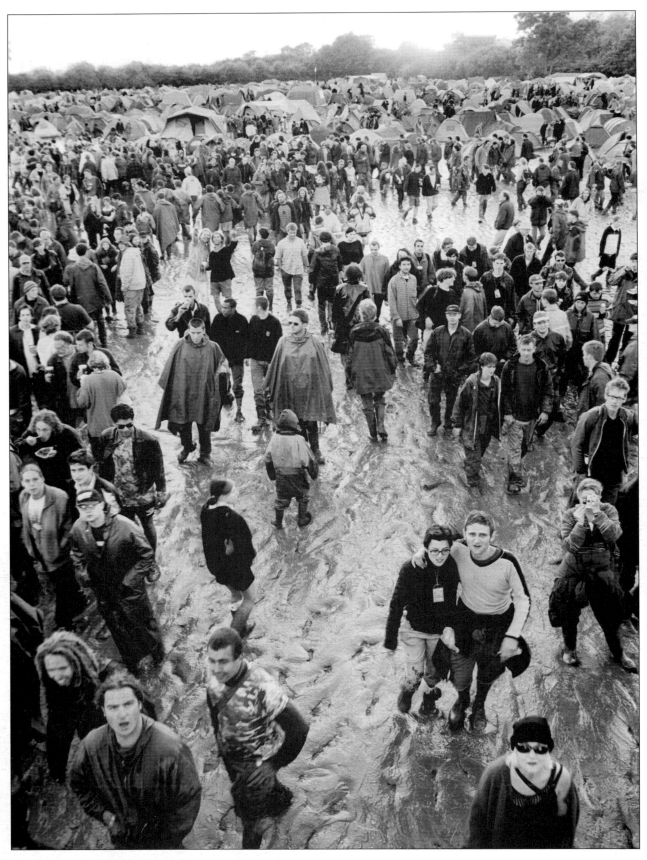

Synchronously one of the anagrams of Glastonbury is URL Nasty Bog.
As it happens another is Yur Last Bong (and there are many more…).

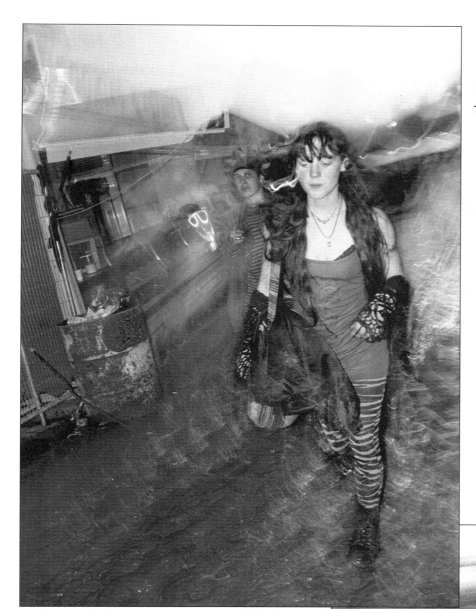

Through the mean streets of
the ephemeral city she strides,
self-possessed, her worldly
belongings slung over her shoulder.
The haunted, amphetamine stares of
the 24-hour stall-holders slide from
her shoulders like rivulets of rain
off a well-waxed tarpaulin.
It has to be said, you get a better
class of bag-lady at Glastonbury.

A young man on his way to see Blur.

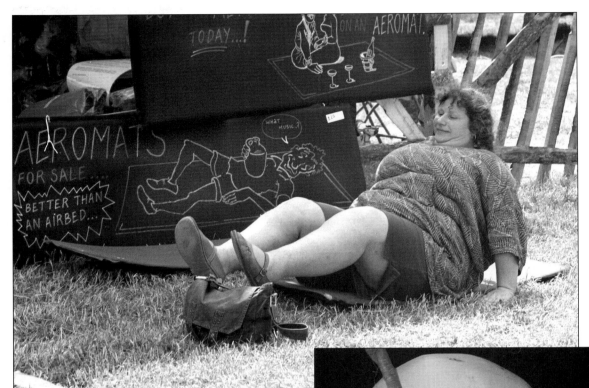

For many, the festival is a chance to reinvent and transform themselves; to bring forth new aspects of character. Here a woman gives birth to a fashionable handbag.

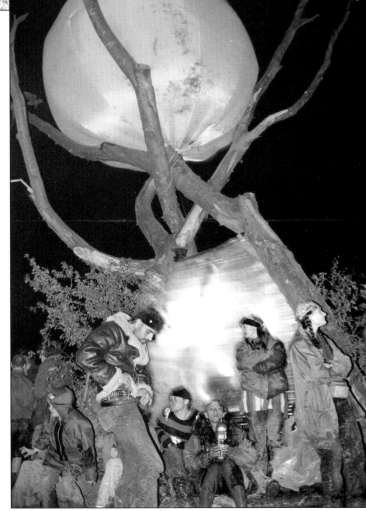

In the past, many thousands have scaled the fence or even tunnelled their way in. This was the only attempt we know of by hot air balloon under cover of darkness. Up until 2002 the scientific name for the fence round Glastonbury was 'Permeable Membrane'.

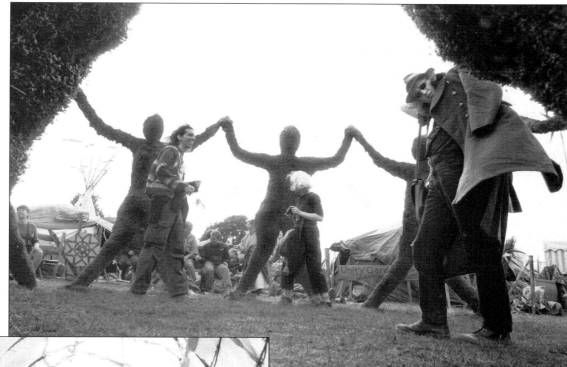

A sophisticated example of choreographed topiary. Shrub-shaping was originally a subversive, anti-establishment form, the only redress of the disenfranchised under-classes. A pair of sharp shears was the spray can of the militant serf. If you tell modern suburban topiary enthusiasts about the radical origins of their craft, they can get quite prickly.

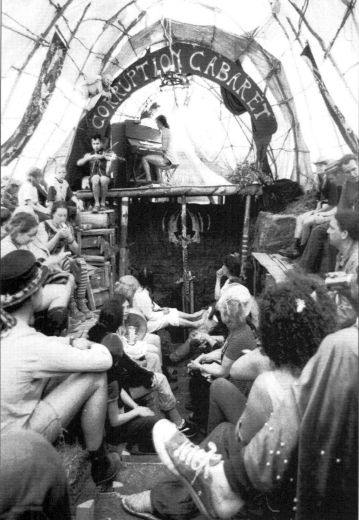

All this takes place inside the skull of the man on page 11. It looks more contemplative than corrupt. Calling it Corruption Cabaret doesn't mean they accept bribes or offer lucrative arms contracts to their pals in the military/industrial complex; it's more to do with promoting liberal attitudes towards harmless hedonistic practices. We think.

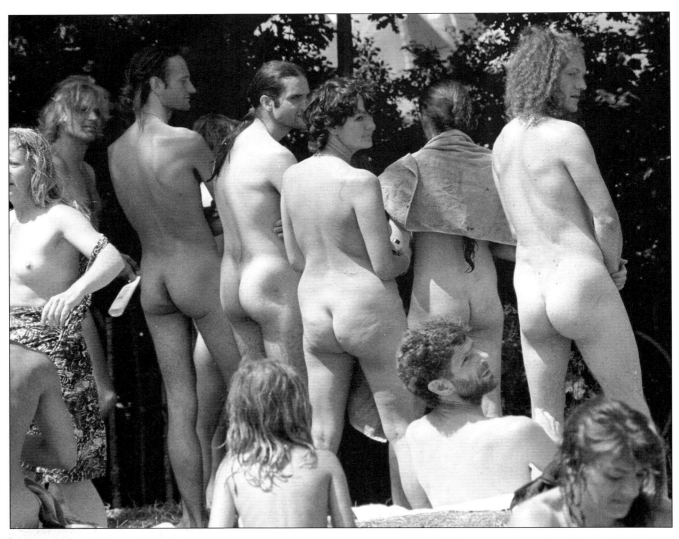

It's lovely to see so many bare bottoms –
symbol of innocence and vulnerability.
Here we see a group of enthusiasts clenching
and unclenching their buttocks to generate
electricity for the Green Futures Tent.

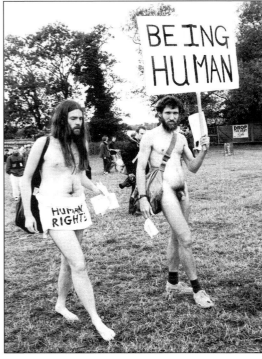

These men are protesting for their right to wear shoulder-bags.

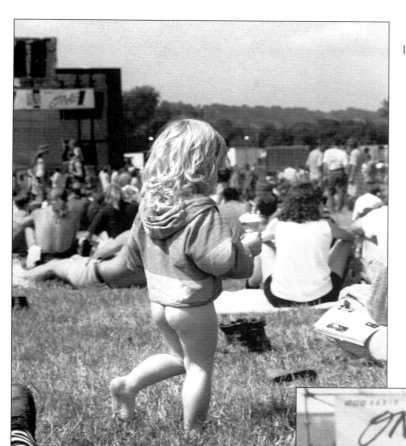

In an everyday re-enactment of Arthurian legend, this reincarnation of the pure knight, Parsifal, returns triumphant from his quest, proudly bearing the Grail cone, which can salve all wounds of body, mind and spirit. Unfortunately, he eats it on the way back.

Although he may be seen as claiming his pre-fall Edenic right to walk naked and unashamed, asserting the inherent dignity of the unadorned human form, this man has genuinely lost his underpants.

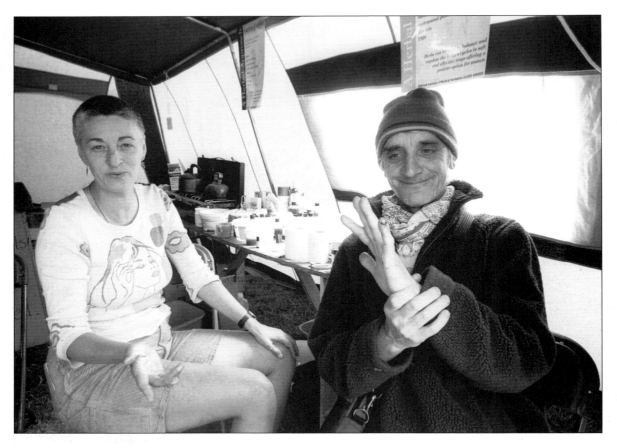

The first aid tent offers a range of treatment from homeopathic remedies through to the sewing on of lost limbs, as shown. They now also offer counselling for shamanic depression. Previously, sufferers were just given a cup of tea and a social services leaflet entitled 'Coping with Ectoplasm'.

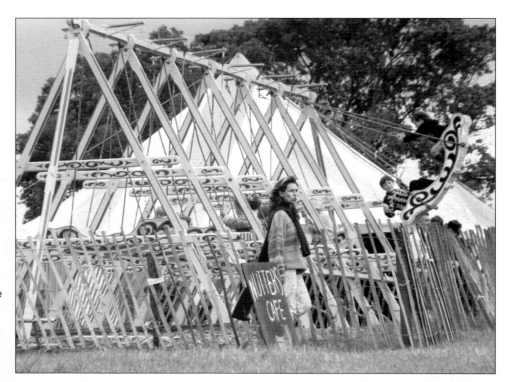

Swing boats at Nutters Café – fools rush in where angels spill their tea. "Mummy, can we go to Centre Parcs next year?"

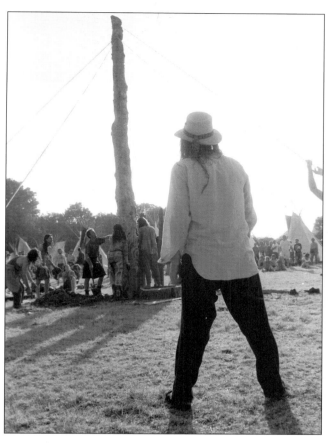

A man pauses in reverent contemplation
before a recently erected phallic symbol.

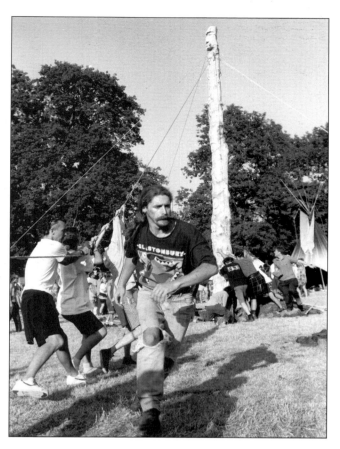

Another man, bewildered by his own sexuality,
uncertain about his role as a man in today's society,
overwhelmed by the latent power of his masculinity and
the responsibility that entails, legs it for the beer tent.

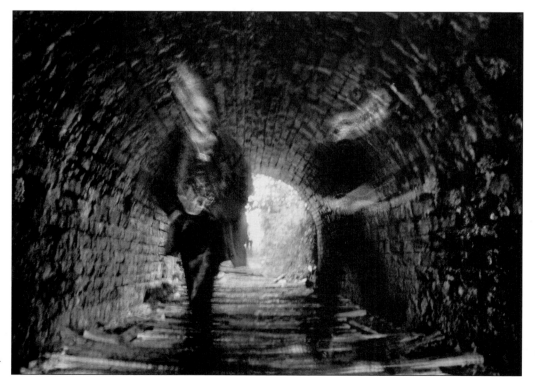

In the subway between
the Green Futures and
the Healing Field,
leering dream-figures
stalk the shadowy
corridors of the
collective unconscious.
Oh yes they do.

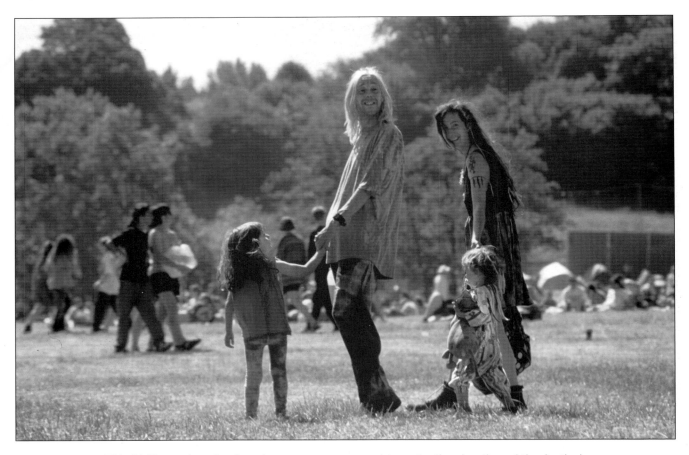

This idyllic nuclear family only assumes corporeal form for the duration of the festival.
The rest of the year they exist as a nice idea, and live on Invisibility Benefit.
We would buy just about any product endorsed by them.

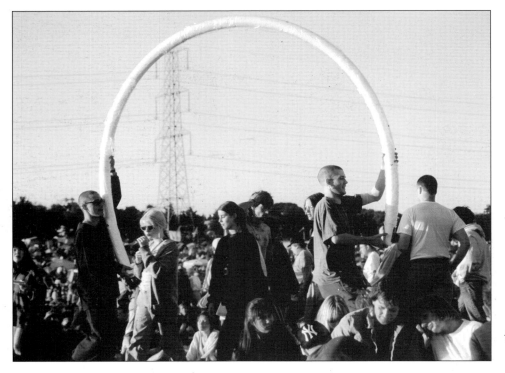

These two community-spirited young men, inspired by ideals of co-operation and recycling, have collected an enormous number of used plastic beer glasses and fashioned them into a gateway to another dimension.

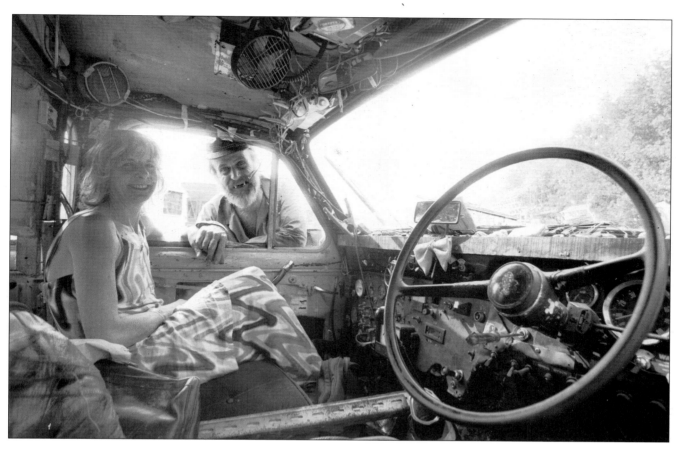

Not all vehicles at Glastonbury have a current MOT certificate, although some have been designated sites of special scientific interest. We're interested in alternative technology, complementary medicine and cutting-edge psychotherapy, and have been involved in a project to develop a car that runs entirely on suppressed rage. We started with a scooter powered by anxiety, but this used to speed up when it came to a hazard.

Rather than bury our heads in the sand over the expected depletion of fossil fuels within the next twenty years, now, more than ever, we need innovative and imaginative alternatives. This couple, seen here swapping hair care tips with a young girl, have travelled from Llandudno on pretend birds.

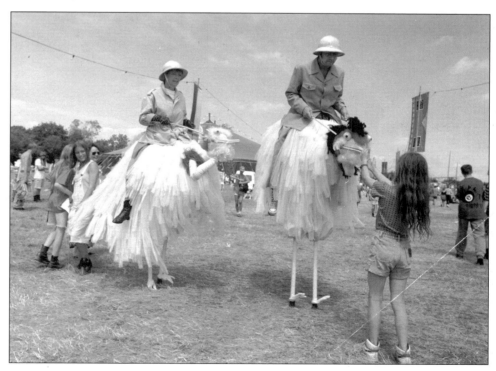

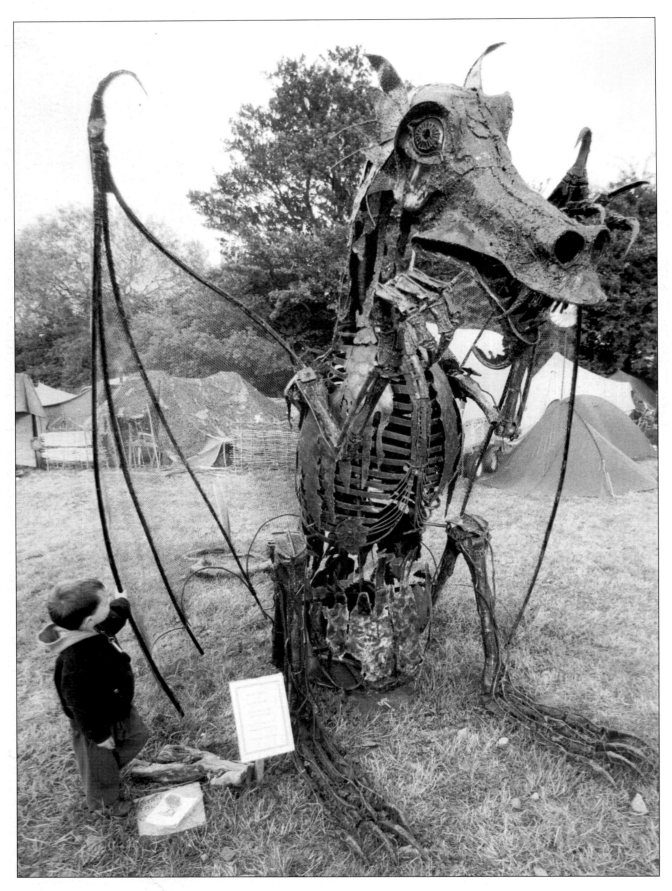

Mummy, can we go home now? Mummy? MUMMY!

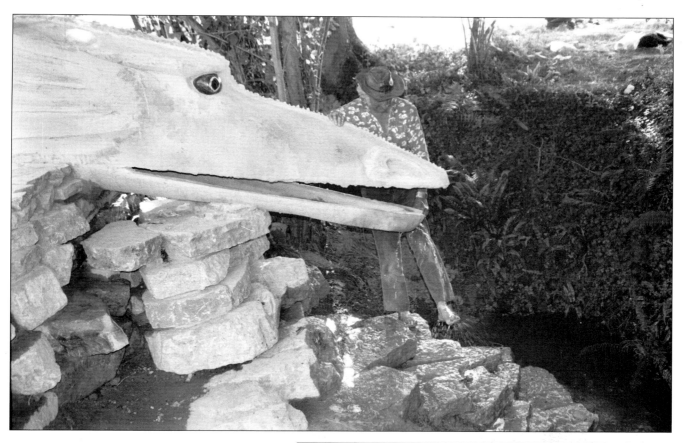

Dragon saliva,
ancient remedy for athlete's foot.

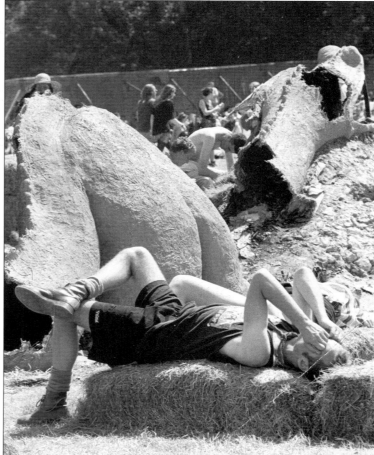

An impromptu on-site archaeological dig
reveals that before the 'beaker people' there
were the 'community arts project people'.
Little has changed, really.
People are people whenever you go.

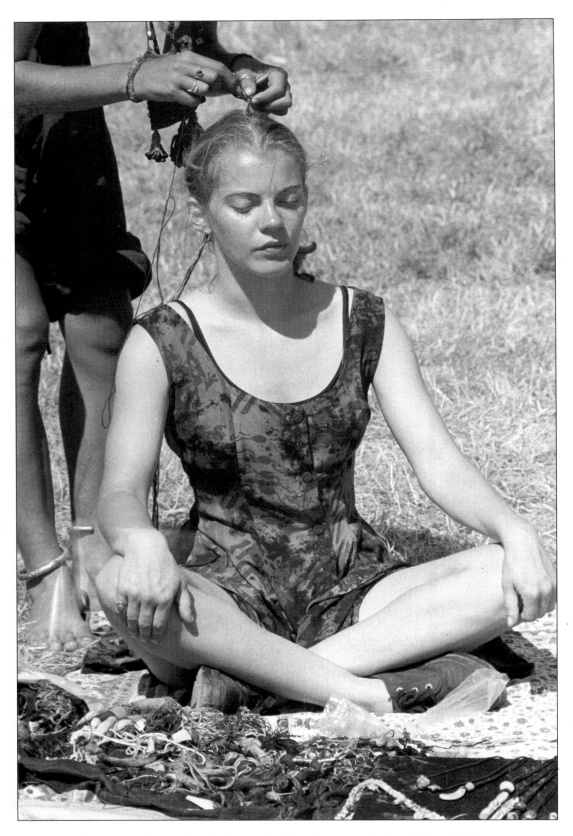

Many people are afraid to leave their heads unguarded whilst meditating,
but this woman is the lucky recipient of surreptitious personal grooming.
While some might see this as an infringement of personal liberty,
others would say this is nit-picking.

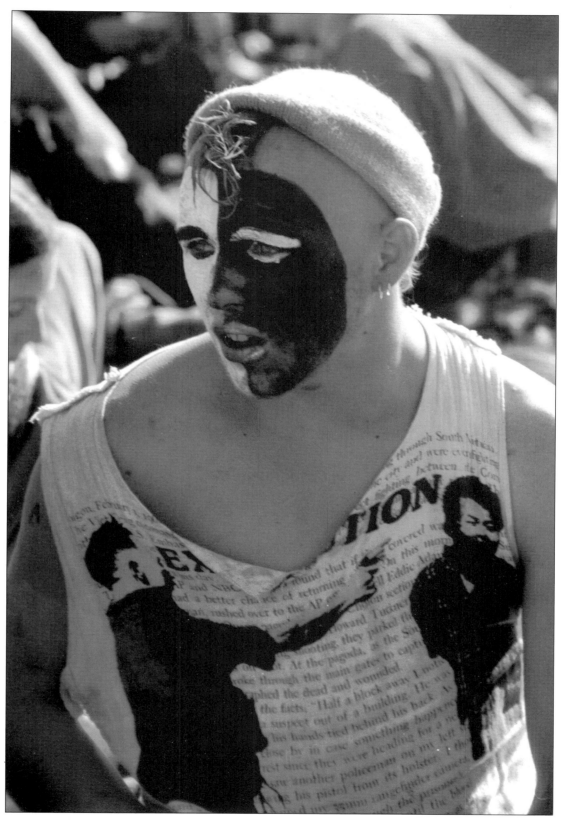

Since being dropped by ITV in the mid-70s, the Black and White Minstrels
have re-assessed their core values and are trying to re-establish themselves
as committed eco-activists.

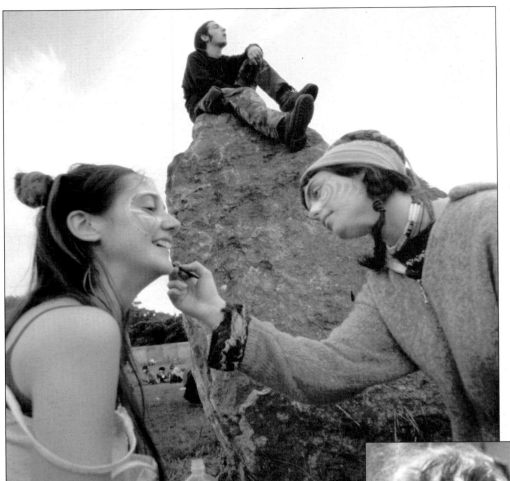

At Glastonbury many people find themselves reverting naturally to old tribal ways. Here we see two girls painting their faces in preparation for going out on the Solstice, while the man in the background stays in the camp, guarding the stash.

She gazes wistfully into the middle distance wondering whether she'll be going to the Rave Tent, the Travelling Sauna, or to see Van Morrison on the mainstage. All depends on the shape of crystal he pulls from the basket.

Glastonbury
– a place where garden
ornaments can relax
and be themselves.

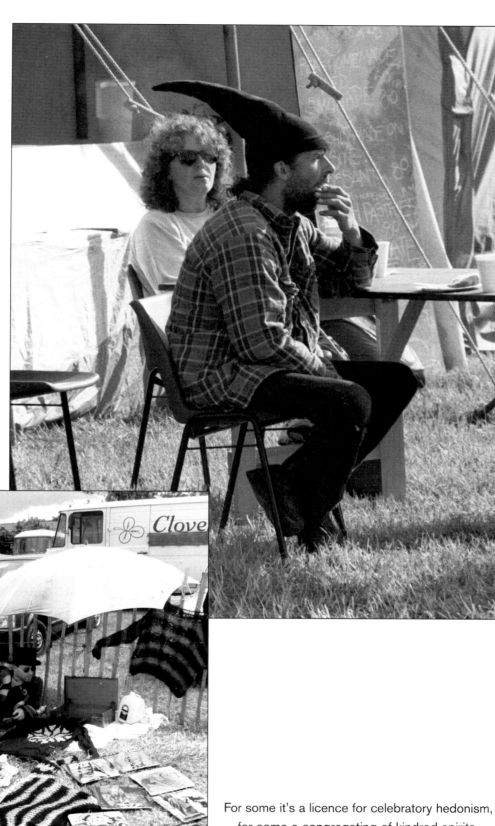

For some it's a licence for celebratory hedonism,
for some a congregating of kindred spirits,
where the marginal become central and the
underground overground... erm, wombling free.
For others it's just a really big car boot sale,
with bands.

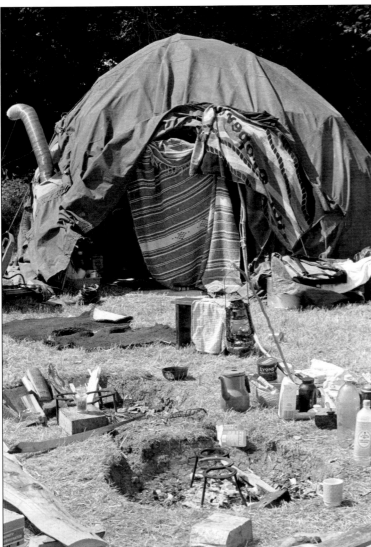

They've developed a bong which takes out people but leaves tents and camping equipment completely unharmed...

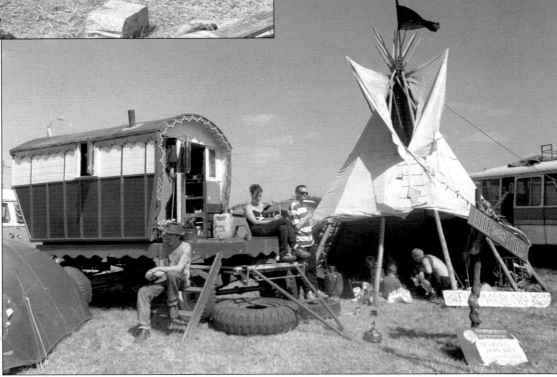

The full Nomad range from Millets.

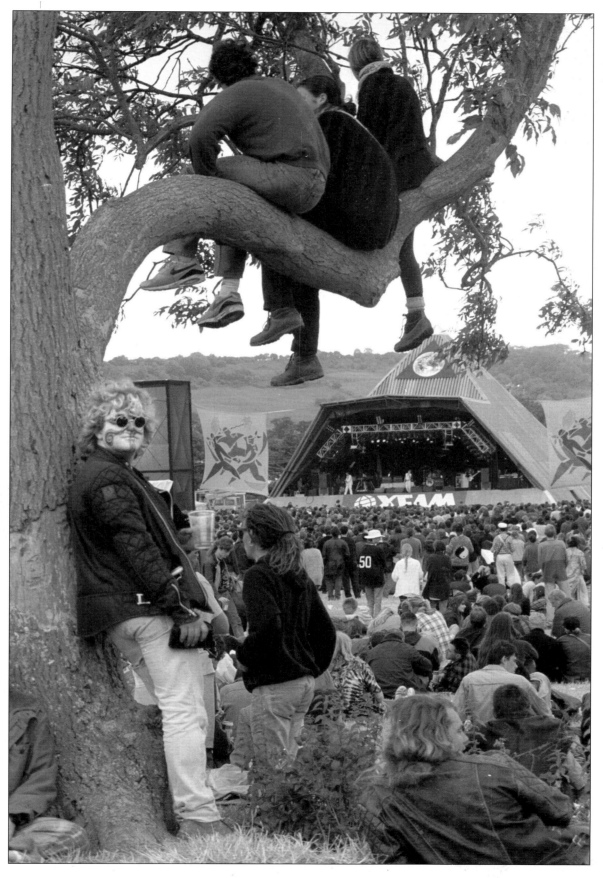

Does my mind look big in this?

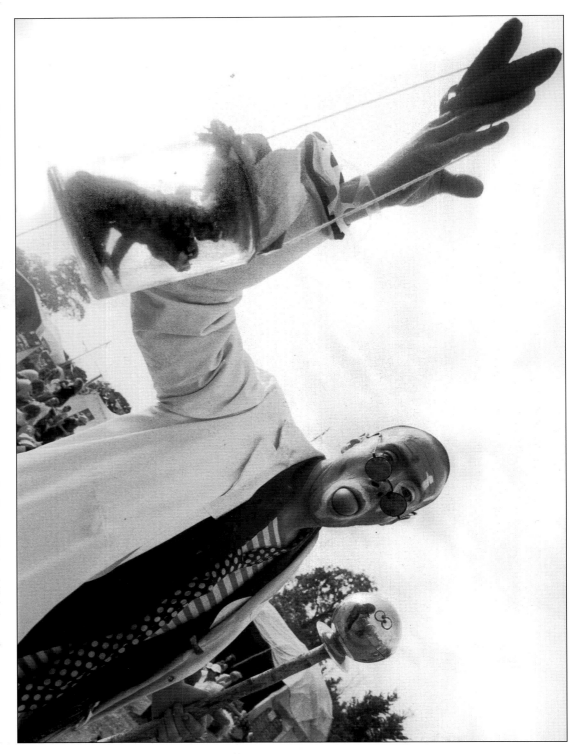

Traditional fairground games can still be found. This man won a genetically modified goldfish from the Monsanto stall, for successfully integrating his DNA with that of a Cox's Pippin.

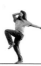

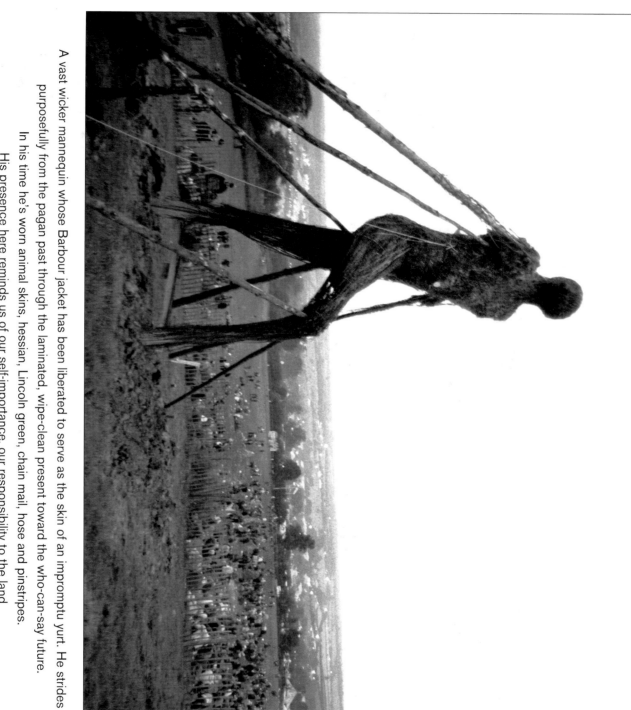

A vast wicker mannequin whose Barbour jacket has been liberated to serve as the skin of an impromptu yurt. He strides purposefully from the pagan past through the laminated, wipe-clean present toward the who-can-say future.

In his time he's worn animal skins, hessian, Lincoln green, chain mail, hose and pinstripes.

His presence here reminds us of our self-importance, our responsibility to the land and our innate tendency to biodegrade.

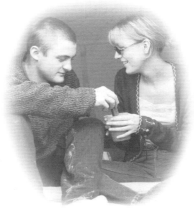
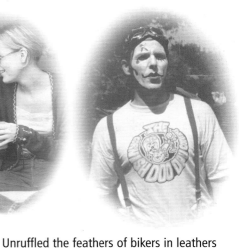

The Innocent Everyday Ocean

by Matt Harvey

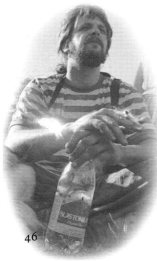

Many's the many who haven't a penny
And too are the few who speak true
And sore is the rawness of people whose poorness
Discolours the deeds that they do

For hurly the burly that wakes us so early
And puts us to bed when it's late
And gravy the train that we're riding in vain
'Til the pattern is licked off our plate

Unchecked are the jackets of punters in packets
And snide is the back of their stab
And tongue-tied the twisters who give themselves blisters
So glib is the gift of their gab

For thin are the thinkers who walk round in blinkers
And etched is the stretch of their smile
Singing "Such is the suchness of all of our muchness
That wide is the width of our while"

Unruffled the feathers of bikers in leathers
And roughshod their ticket to ride
While sunbathers toil beneath lashings of oil
Until tastefully tanned is their hide

And fleeced are the flock that live chock upon block
And jowel by bowel to boot
While they're licking their lips over fat fish and chip
Someone's picking the lock of their loot

A man with a mangle has found a new angle
He's set up a new scene to steal
When he gets to the bank he knows just who to thank
But he's fallen asleep at the wheel

Unhitched are the hikers who think they don't like us
The more we drive past in our cars
There's always a catch or an itch you can't scratch
Like a haemorrhoid far up your arse

And pearly the gates where the Lord Jesus waits
With his merciful scales in his hand
If you're caught in arrears then He'll wipe off your tears
And He'll set you down safe on dry land

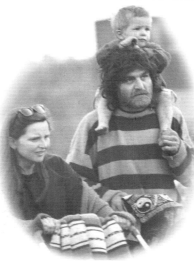
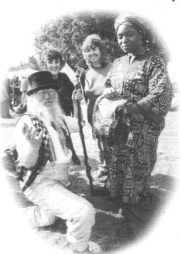
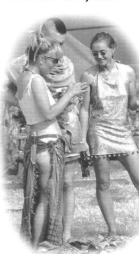

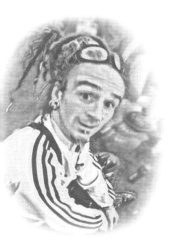

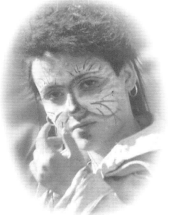
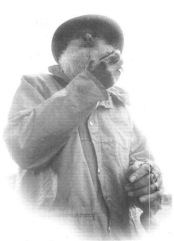

A sign in the suburb said: Do not disturb
While our daughters are trying to diet
here's a hard garden gnome standing guard on our home
And he'll kill for some peace and some quiet

A young woman curses and clicks shut her purse as
The Good Shepherd shuts up his shop
She married a butcher who sawed off her future
Then came home and gave her the chop

She knew what to do for her dreams to come true
But she got off to such a false start
hile the young man was fishing for the price of admission
She was hoping to hump off his heart

You win some you lose some you grow a big tum
Where there maybe a baby inside
When it enters the world be it boy beast or girl
It's got nothing whatever to hide

So we send it to schools where they ram home the rules
With an iron hand in a kid glove
Sweet voices of reason speak words of pure treason
To sandwich the language of love

So harmless the gormless whose thoughts are so formless
Our jawbones hang open in shame
We're taught to wear nylon and hats with a smile on
To labour, lay bets and lay blame

And humpty the dumpty whose life is so empty
He spends all his days on a wall
There's nothing inside but his terrible pride
To come between him and his fall

While cross-legged commuters caress their computers
(So mild are their manners, and meek)
Torrential the tears that run down our careers
Until blub is the chub of our cheek

And staid are the stable who do what they're able
Precise, to the point, are their prayers
And crazy the paving of those who are slaving
Or drowning by numbers in pairs

And sung is the song of the sad and the simple
And dug is the ditch of their deep
And soft are the screams that encircle our dreams
So sound is the snug of our sleep Our sleep
So sound is the snug of our sleep

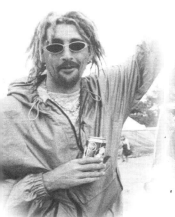
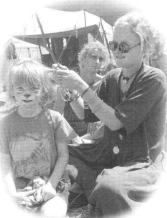
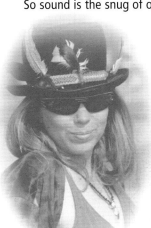
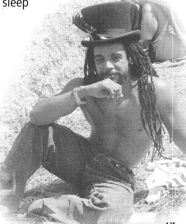

47

Publications

Matt Harvey and Rory Motion are familiar voices on BBC Radio, having written and performed two series of their own show, One Night Stanza, for Radio 4. They also perform, separately and together, in cabarets, festivals and conferences in a variety of venues around the British Isles.

www.onenightstanza.co.uk

Neither is the Horse and Other Poems, by Rory Motion, (published by Cassell & Co),
is available in all good bookshops,
price £6.99 ISBN: 0–304–36241–7

"The first collection of poems by Huddersfield's legendary poet laureate. Here between the covers for the first time, we can sample the best of Rory Motion, from his now classic *Albert and the Rave* to his very latest inventions, including Pigeon Healing and his poem about the Edinburgh Festival, *Fear of Las Vegas in Lothian*. If you've ever wondered about the role of chutney in tantric sex, or the inner life of a Viking, or what you might say to Bob Dylan on a chance encounter in a wholefood store, then that's a happy coincidence because Rory touches on all these things within this book."

Think
Think globally act locally
Think cosmically act stupidly

www.rorymotion.com

Matt Harvey has published four books: *Here We Are Then*, *Songs Sung Sideways*,
Standing Up To Be Counted Out and *Curtains (and Other Material)*
price £3.99 each plus 20p per book p&p

These can be purchased by sending a cheque, or postal order, made out to Matt Harvey to:
3 Vineyard, Dartington, Totnes, Devon TQ9 6HW.
Or by phone: 01803 840759. Or online at the website address below.

"Mr. Harvey's poems can be enjoyed by readers of all ages, backgrounds and body-types. They speak tenderly of love lost and mislaid, they touch gently on haemorrhoids and deal admirably briefly with the nature and meaning of time. They have proved as popular with the dynamic 'Let's-get-up-and-change-the-world' person as they have with the more retiring 'No-let's-not-I-have-a-sore-wrist' individual, and possess strong appeal for all those in-between."

To a Special Slope
You're such a radiant gradient
A smooth one, not a hilly one
Your red-rimmed sign says you're one in nine
But to me you're one in a million

www.mattharvey.co.uk